FACE
PAINTING

JACQUELINE RUSSON

With photographs by Zul Mukhida

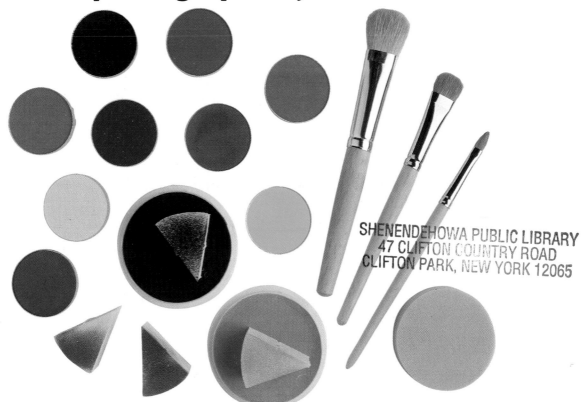

Thomson Learning • New York

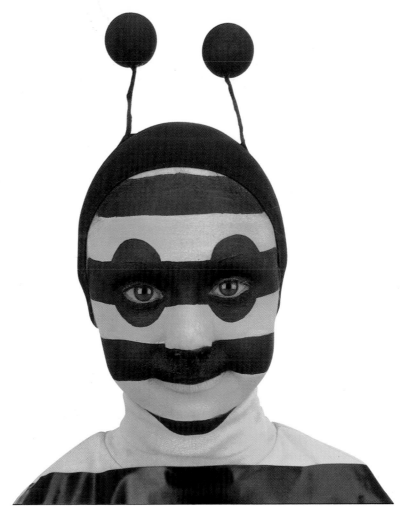

First published in the
United States in 1994 by
Thomson Learning
115 Fifth Avenue
New York, NY 10003

Published simultaneously in Great Britain by
Wayland (Publishers) Ltd.

Library of Congress Cataloging-in-Publication Data
Russon, Jacqueline.
 Face painting/Jacqueline Russon; with photographs
by Zul Mukhida.
 p. cm.
 Includes bibliographical references and index.
 ISBN 1-56847-197-1
 1. Face painting—Juvenile literature. [1. Face painting.]
I. Mukhida, Zul, ill. II. Title.
TT911.R87 1994
745.5—dc20 94-12200

Printed in Italy

CONTENTS

GETTING STARTED

This book is full of ways you can paint your face. All of them can be done with little effort. You do not need to be a great artist to get striking results. If you follow the basic rules and techniques outlined here, you can't go wrong.

Your face painting may not turn out exactly like the photographs in this book. The result depends on the face of your model and the colors you choose. You can also use your own ideas. Have fun!

EQUIPMENT

Makeup
All the faces in this book are painted with water-based makeup. It is safe and easy to apply and remove. It can be washed off skin and clothes using soap and water. Water-based makeup can be bought from most art supply stores and makeup suppliers.

Only use makeup specifically designed for the skin.

Water-based makeup mixes like paint, so you can produce a wide range of colors.

Sponges
These can be bought at drugstores or from makeup suppliers. After use, wash the sponges in warm, soapy water and rinse them well.

Brushes
These can be bought at drugstores or makeup suppliers. You can also use good-quality art brushes. You will need several: a small, thin one for detailed work; a couple of medium-sized brushes; and a large, flat one for filling in big areas.

Other equipment
- Tissues for mopping up spills or mistakes.
- A large jar of clean water for rinsing brushes between colors.
- A towel or smock to protect your model's clothing.
- A headband for keeping hair off the face.
- An old toothbrush for coloring hair.

TECHNIQUES

Using a sponge
To apply a base, dip the sponge in water, give it a good squeeze, then wipe it over the base makeup. Dab the sponge around the outside of the face, then fill in the rest. If the sponge is too wet the makeup will streak unevenly. If it is too dry the makeup will be difficult to apply.

Using a brush
It is usually a good idea to make an outline and then fill in the color. Be extra careful when using a brush around the model's eyes. Ask your model to look up, away from the brush. When painting lines over the eyelid, do not let your model squint. This will make a mess and paint may get into the model's eyes.

Blending color

You can blend colors on the skin to give a soft effect. First, apply the base color and let it dry. Apply another color using a sponge that is barely wet. Gently dab the colors together. If there are any harsh edges, you can fade them with a dry sponge that has no makeup on it.

Extra effects

- Use makeup to color hair. For large areas, apply it with a sponge or brush. For just a little color, use an old toothbrush. Wet the paint as usual.
- Buy glitter gel designed for use on the face and body. Do not use the kind made to decorate paper.

COSTUMES

A good base for many costumes is a polo shirt and tights or leggings. Then add one or two extras for the finishing touch. Try starting a dress-up box – collect old clothes, pieces of fabric, hats, and so on. You can also make your own costume extras.

LITTLE MOUSE

This is a simple face to show you the basic face-painting techniques.

1 Sponge on a white base and let it dry. Then paint the nose with pink. Painting a gray arch from one corner of the eye, up over the eyebrow, and down to the other corner of the eye.

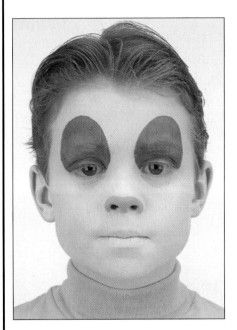

Repeat on the other eye. With your model's eyes closed, carefully fill in the arch shapes with gray paint.

2 With a thin brush and a steady hand, paint in two small black eyebrows. Using the same pink paint as for the nose, paint a curly mouth over the top lip.

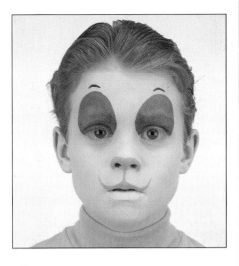

3 Finally, add whiskers. Using the tip of a small brush, dab black dots at the corners of the mouth. Then paint in lines for the whiskers.

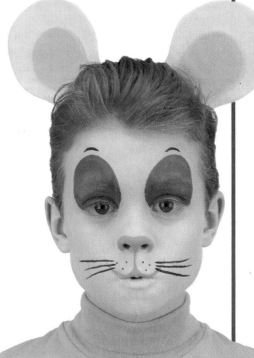

Costume ideas

Cut two round ears from thick paper. Cover them with white and pink felt and attach them to a headband.

CLOWNS

Circus clowns use lots of makeup to look happy or sad.
Either way, they always make people laugh! A Pierrot is a sad clown
from France. Pierrots always have white faces.

HAPPY CLOWN

1 Sponge on a white base. Dab red makeup on the cheeks and on the end of the nose. Paint a thin, black outline around the white base.

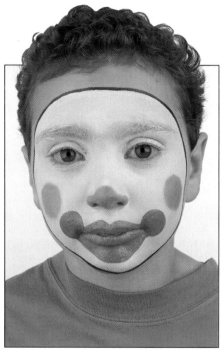

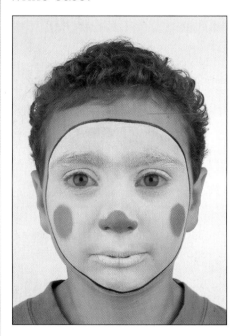

2 Paint a big, red, smiley mouth. Put makeup over and around your model's mouth to make it look much bigger.

3 Using green makeup, paint two arches over the eyebrows and under the eyes.

4 Outline the arches in black. Paint bright shapes above the red circles on the cheeks. Outline these shapes in black.

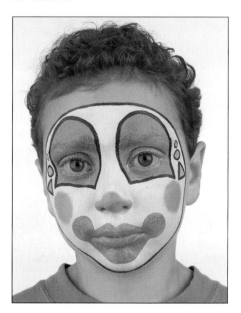

Costume ideas
Find or rent a funny wig. Wear baggy trousers held up with suspenders and a brightly colored shirt.

PIERROT

1 Sponge on a white base. Using a dry sponge, blend pink circles on the cheeks.

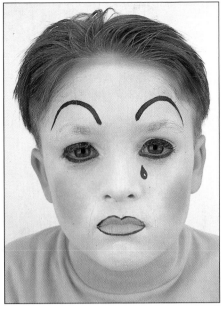

3 Color the lips pink, making a curvy shape. Outline the mouth in black. Add a white dot to the tear, to make it shine.

Costume ideas
Make a Pierrot's cap out of the top of an old black stocking. A ruff around the neck will complete the effect.

2 With a thin brush, paint high black eyebrows and outline the eyes. Paint a tear just below one eye.

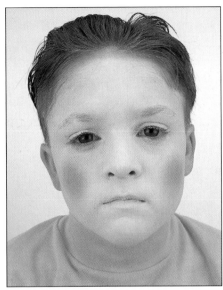

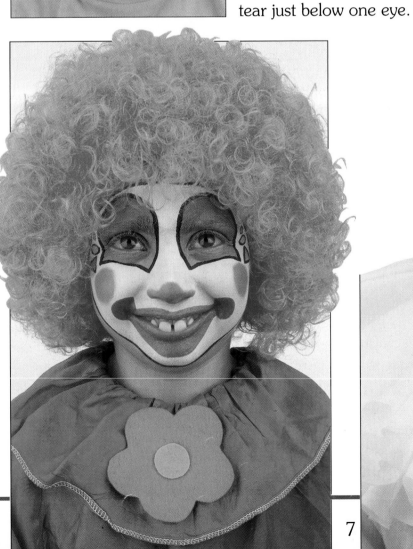

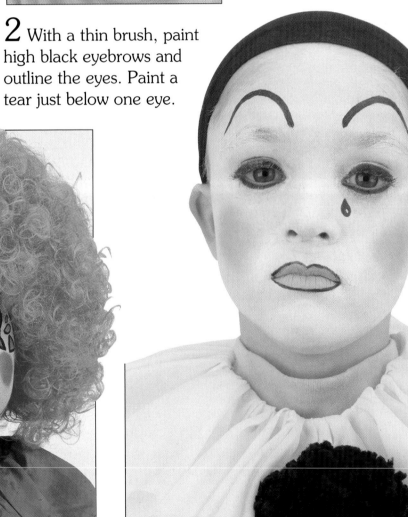

GOING WILD

Tigers and zebras have striped skins. Do you know why? The stripes help them blend in with the trees and grasses around them. This way, they can hide from other animals. Can you think of other wild animals with stripes?

TIGER

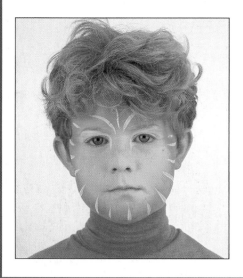

1 Sponge a yellow base on the face. With a sponge, blend orange around the outside of the face. Let this dry.

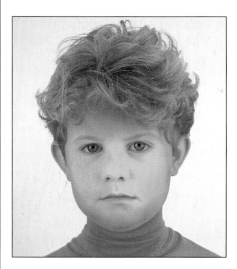

2 Paint white over the eyelids and into points at the inner corners of the eyes. Smudge it with a dry sponge. Using the tip of a brush, paint white triangular stripes around the outside of the face.

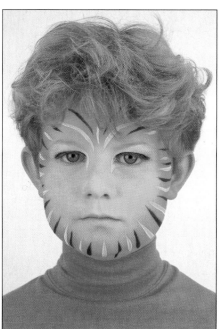

3 Using the same brush, paint black over the eyelids. Smudge it with a dry brush. Then paint black triangular stripes between the white ones.

4 Color the end of the nose black. Paint a black line from the tip of the nose to the top lip. Color the mouth black as well. Paint dots for whiskers on either side.

Costume ideas

Cut out two ears from cardboard or thick paper. Color them orange or cover them with orange felt and paint on black and white stripes. Attach them to a headband.

Make a tail from a long piece of fabric and pin it to a T-shirt or top.

▼▲▼▲▼▲▼▲▼▲
Handy hint
Keep the brush as wet as possible when painting the stripes. This will give you a good, smooth line.
▲▼▲▼▲▼▲▼▲▼

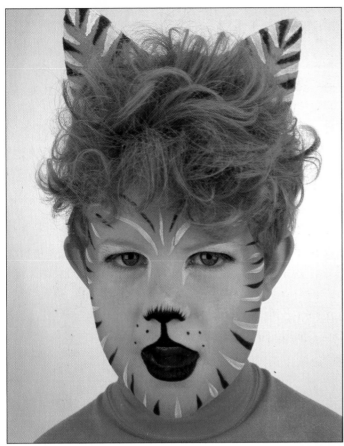

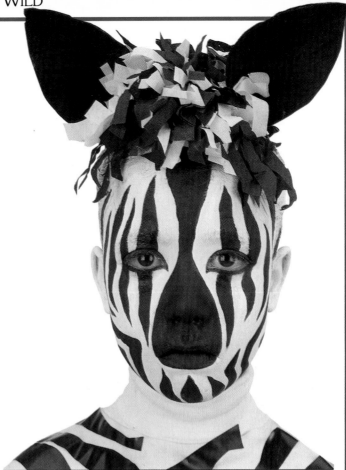

ZEBRA

1 Mark the zebra's white stripes on the face. Paint them in. Apply two coats of paint, allowing them to dry thoroughly before going on to the next step.

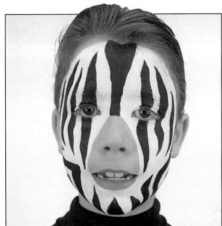

Costume ideas

Make a mane out of black and white crepe paper, cutting it for a fringed effect. Cut ears from thick paper or cardboard and cover them with black felt. Attach the mane and ears to a headband.

2 Using a small brush, paint two coats of black stripes between the white ones.

3 Paint a big black nose over the model's nose and mouth. Paint a pointed black outline around each eye.

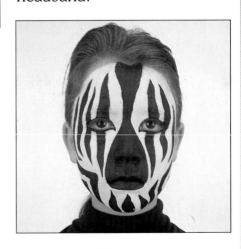

THE SEASONS

We all have a favorite time of year. Different things remind us of different seasons. There may be snow in winter, new flowers in spring, sunshine in summer, and golden leaves in autumn. You can paint the four faces the way they are shown here, or you can add seasonal ideas of your own.

SPRING

1 Blend areas of peach and pale green all over the face with a sponge.

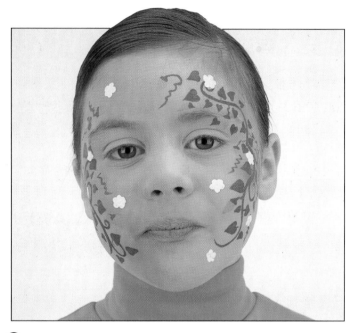

3 Mix together a pink color. Paint flower buds on the stems. Now add white flowers.

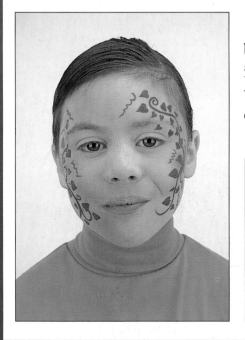

2 With a small brush and bright green makeup, paint in stems and leaves around the eyes and down the cheeks.

4 Outline the buds with dark pink and the leaves with dark green. Put a blob of yellow in the middle of each flower.

▼▲▼▲▼▲▼▲▼▲▼▲▼▲▼▲▼▲▼▲▼▲▼▲▼

Handy hint
Many of these shapes are very delicate and the outlines are extremely fine. Use a very thin brush, or make your own by cutting a larger one into a small point with scissors.

▲▼▲▼▲▼▲▼▲▼▲▼▲▼▲▼▲▼▲▼▲▼▲▼

SUMMER

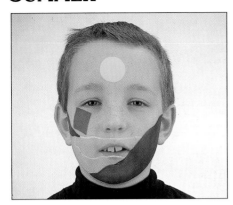

1 Wet a small brush. Wipe it around the white makeup so that you have a thin, watery color on the brush. Outline areas for the sun, kite, and land. Fill in the shapes with the appropriate colors.

2 Using a large brush, dab white makeup where the clouds will go. Paint in the blue sky and smudge the two colors together with a dry sponge.

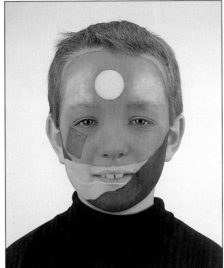

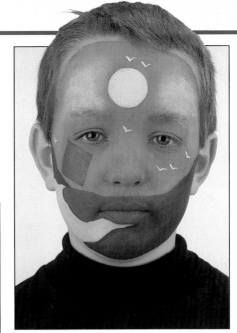

3 The next step is to color the sandy beach yellow and the sea dark blue. Using the tip of a fine brush, paint white V-shapes for birds.

4 Finally, make a black outline around the kite. Draw a cross on it and add a long string. Then, using different, bright colors, add bows to the kite tail. Outline these in black.

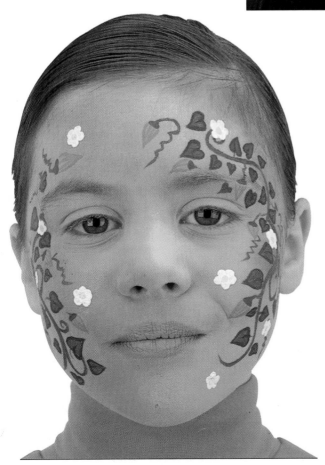

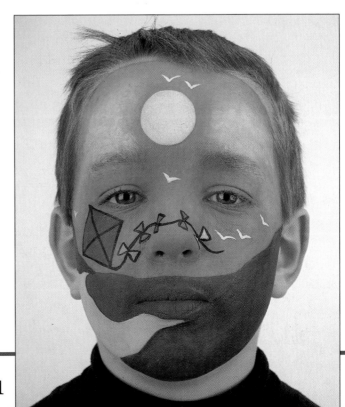

AUTUMN

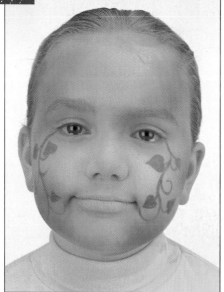

1 Sponge a golden-yellow base over the face. Blend orange and brown around the outside. Using a fine brush and green makeup, color in the ivy down each cheek.

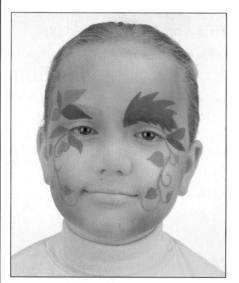

2 Mix together different shades of brown, orange, and green. Paint in leaves in different colors around each eye and on the cheeks.

3 With a small brush and purple paint, color in berries by painting six dots in the shape of a triangle. Add small red berries as well.

4 Using dark brown paint, outline the leaves and draw the veins. Do the same with dark green makeup around the ivy.

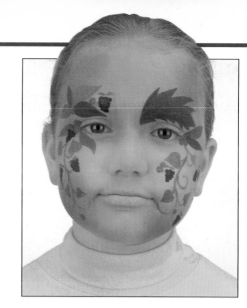

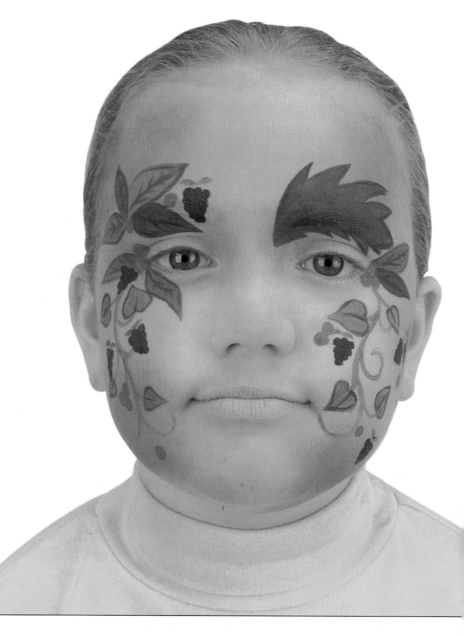

WINTER

1 Outline the white snow and snowman shape across the bottom of the face. Fill in with white paint. Then paint the rest of the face blue, leaving a space on the forehead for the sun.

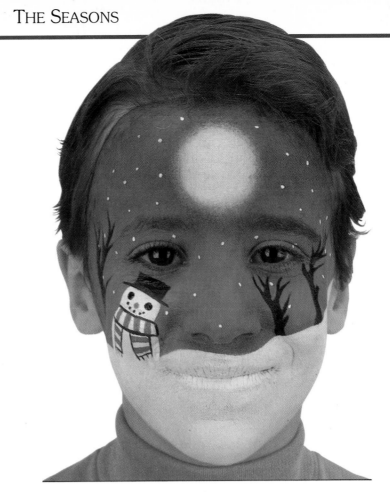

2 Paint the sun pale yellow, then smudge the edges with a dry sponge to make it look hazy. With the tip of a brush, dot white snowflakes all over the face.

3 With a small brush and black paint, draw the snowman's hat. Draw an outline for a scarf. With the same brush, paint bare, black trees.

4 Finish the snowman with two black eyes and a mouth. Paint a bright orange nose and red stripes on the scarf.

▼▲▼▲▼▲▼▲▼▲

Handy hint

When painting white on top of blue for the snowflakes, keep the paint as thick and wet as possible. Otherwise it will mix with the blue. You may need to add two layers of white to make it really bright.

▲▼▲▼▲▼▲▼▲▼

DAY AND NIGHT

Black and white, hot and cold, wet and dry… these are opposites.
Day and night are opposites, too. Every twenty-four hours,
day turns to night and back again. Here is a face showing day and night.

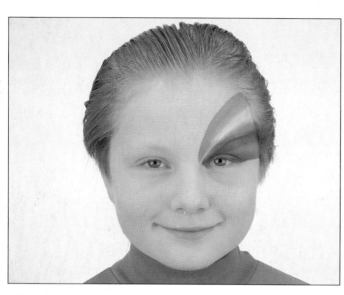

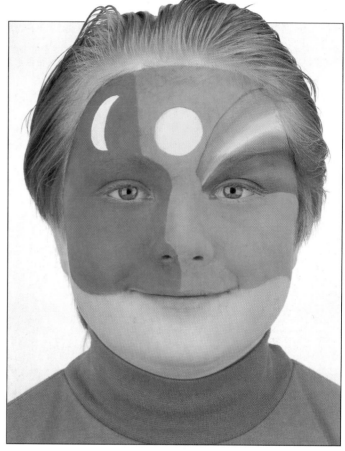

1 First, paint a rainbow over your model's left eye. Do this by outlining the shape, then applying the seven different colors in stripes. Start with red for the outer stripe, and add orange, yellow, green, blue, indigo (dark purplish-blue) and violet (pinkish-purple).

2 Next to the rainbow, paint in a bright yellow sun. On the other side of the forehead, paint a white crescent moon.

3 Now paint around the sun and rainbow with a fairly wet brush and light blue paint, as far as the middle of the face. Repeat this on the other side using dark blue paint. The blue should extend below the nose. Where the two blues meet, blend them with a dry sponge.

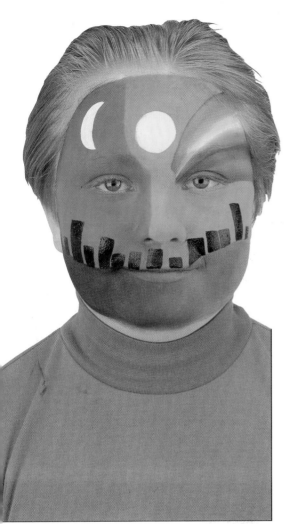

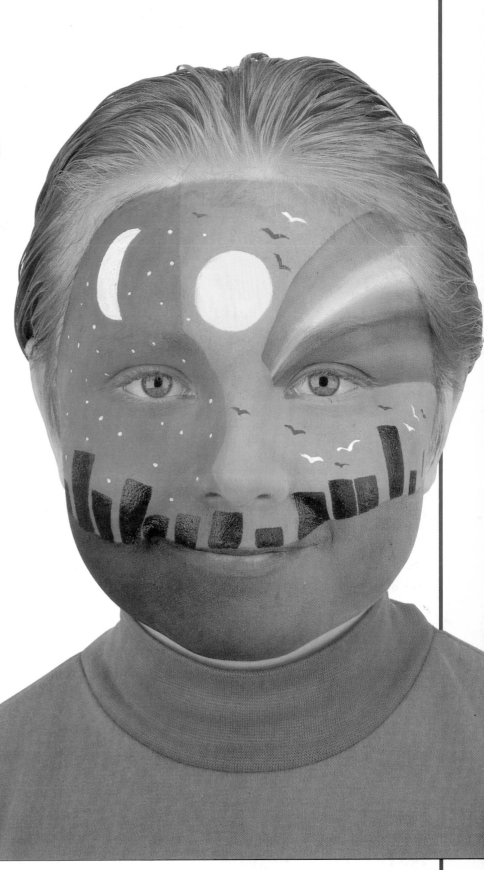

4 Draw a line across the bottom half of the face (it can be sloping) for the land. Color the area from light green to dark green in the same way as you did for the sky. Paint the black shapes of the buildings.

5 With a small brush, paint pale yellow stars around the moon. Finish by painting black and white V-shapes for birds around the sun and rainbow.

BIRDS OF A FEATHER

There are all kinds of colorful birds in the world. Here are three for you to paint.
Look in books to find other birds to give you ideas.
Study the different bill shapes and the colors of the feathers.

BIRD OF PARADISE

1 Sponge a light green base all around the face. With a brush, paint an outline for the yellow beak around your model's nose and mouth. Then fill in with yellow.

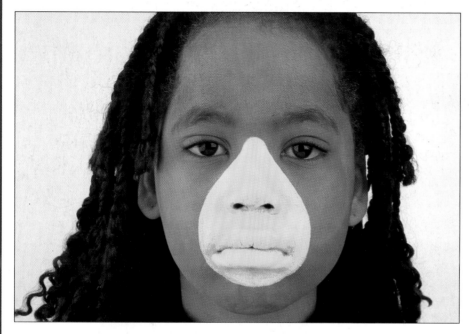

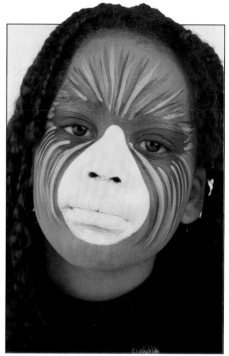

3 Using pink, purple, light green, and orange, paint more feathers over the green base.

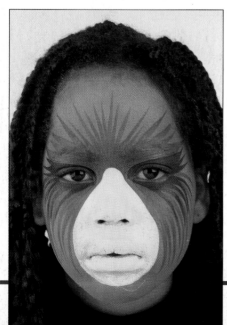

2 With a small brush, paint green feathers over the forehead and cheeks. Ask your model to close his or her eyes and color the eyelids purple. Let this dry, then paint purple feathers under the eyes.

▼▲▼▲▼▲▼▲▼▲▼▲

Handy hint
To make the points on the feathers, paint a line and then, right at the end, flick the brush up and away. Practice on the back of your hand.

▲▼▲▼▲▼▲▼▲▼▲▼

16

4 Paint black over the mouth for a pointed beak shape. Add a nostril on either side of the nose. Paint a black line around the eyes and finish by decorating with gold and green face glitter.

Costume ideas

Wrap feather boas around the head, neck, and arms. Or make a feather headdress – buy a feather duster and take it apart.

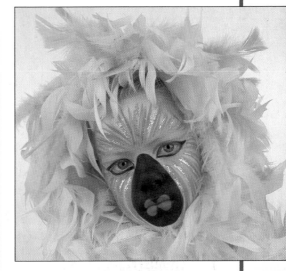

VARIATIONS

The flamingo (above) and eagle (below) are very similar to the bird of paradise. Follow the same steps, but use different colors.

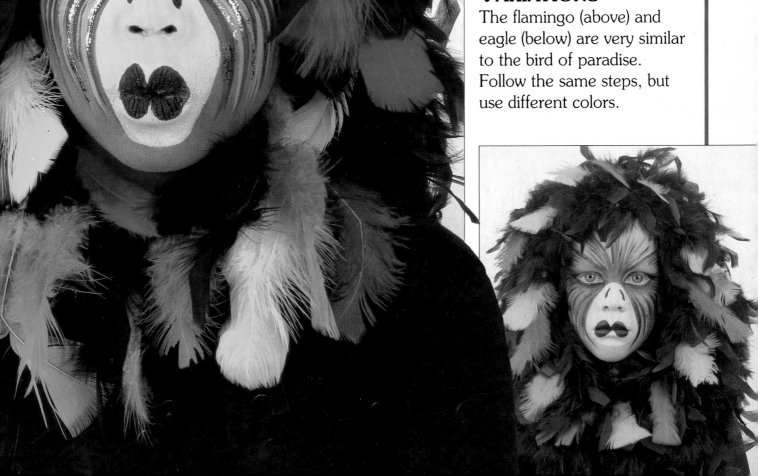

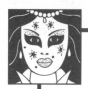

FANTASY FACES

Let's enter the world of mystery and magic. Think of fairy tales you have read. Were they full of magical animals and fantastic people? Try painting this strange magical cat or beautiful snow queen. Look in books or use your imagination to think of other fantasy faces to paint. You can make up a short play about your characters to perform for you friends.

MAGICAL CAT

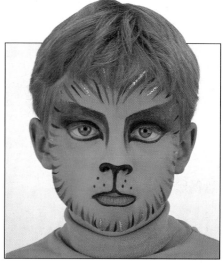

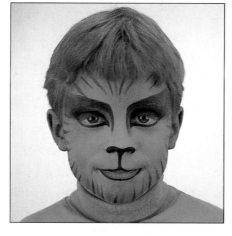

1 Sponge on a turquoise (greenish-blue) base. Blend dark green around the outside of the face with a sponge. Use a brush to paint green triangular stripes around the face. Paint dark green across each eyelid and down the sides of the nose. Smudge it with a dry sponge.

2 Paint darker green lines between the green stripes and over the eyelids. Outline the eyes with black paint and smudge with a dry brush.

3 Color the mouth with turquoise paint and let it dry. Paint the tip of the nose black. Draw a thick black line from the nose to the top lip. With a thin brush, outline the lips in black.

4 With a fine brush and black paint, make dots for whiskers. Add extra black stripes around the face. Finish the face by applying silver glitter between the stripes.

Costume ideas

Cut pointed ears from thick paper or cardboard. Cover them with green fabric and paint on green, black, and silver stripes. Attach them to a headband. Make a tail from a long strip of fabric and pin it to a T-shirt or pants.

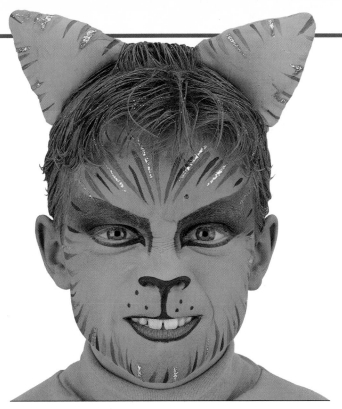

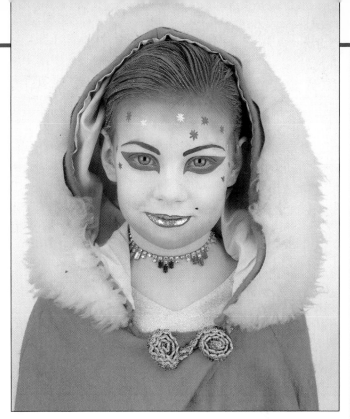

SNOW QUEEN

1 Sponge a white base over the face. Then blend blue around the outside with a sponge. Outline the eyes in blue. Bring the outlines down to a point at the inner corners and up to a point at the sides of the face.

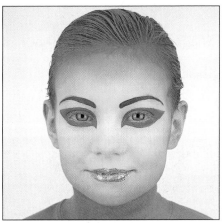

2 With a small brush, paint two dark blue eyebrows. Put silver glitter on the lips.

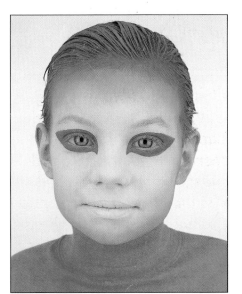

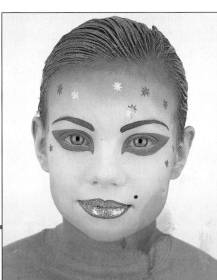

3 Paint white and dark blue snowflakes over the forehead and cheeks. Outline the lips with dark blue paint. Paint a black beauty mark (like a mole) above the lip, on one side. Use your fingers to dab blue and silver glitter onto the hair.

Costume ideas

Wear a long dress made from sparkly fabric and a long cape. Rent these from a costume shop or ask an adult to help you make them.

Buy fake fingernails (at a drugstore) and paint them with silver nail polish (ask an adult to help you).

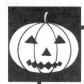

GHOSTS AND GHOULS

Do you dress up for Halloween? In the past, people thought Halloween was a frightening time when witches and other scary creatures roamed about. Today, it is a time for dressing up and going trick-or-treating. These three faces will add an extra flair to your Halloween costume.

DRACULA

1 Sponge a thin white base over the face. Using a sponge that is barely damp, blend gray patches on the cheeks, forehead, chin, and around the eyes. Using a thin brush, paint a red outline around each eye. Smudge it with a dry sponge. Color the lips with watery, gray paint.

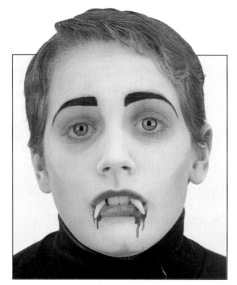

2 Paint two pointed black eyebrows. Drip watery, red paint from the bottom lip to give the idea of blood. Put in some plastic fangs – you can buy these at a costume shop. Color the hair black with water-based makeup or black hairspray.

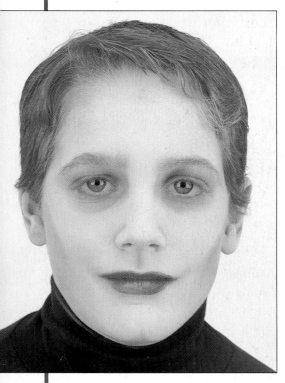

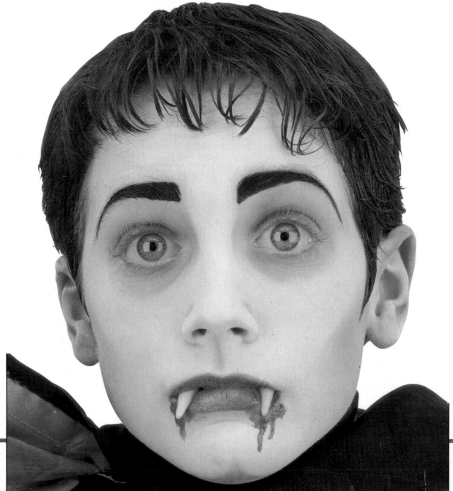

Handy hint

Do not apply too much white base or the face will look clownish. Add white or black paint to the hair to make a more frightening effect.

VARIATION

Make the Bride of Dracula. Paint a basic Dracula face, but color the lips bright red. Add purple eyeshadow to the eyelids and paint a heavy black outline around the eyes. To finish, drip red paint from the corners of the mouth to look like blood.

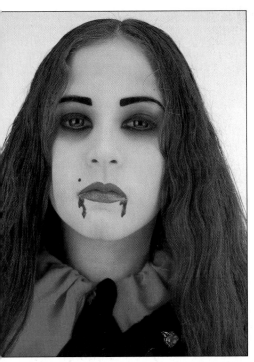

Costume ideas

Wear black clothing and use a large piece of black material for a cape. Dracula's bride could wear a long red or black dress. Wear gloves with big rings on the fingers (ask an adult to help you find some cheap rings).

PUMPKIN FACE

1 Outline a pumpkin shape over the face and color it orange. Paint the rest of the face black.

2 Paint in the green pumpkin stalk at the top. Then, using a thin brush, draw light orange lines down the pumpkin.

3 Using black, paint a triangle around each eye and a smaller one on the nose. Paint a black zigzag shape over the mouth.

Costume ideas

Wear black clothing and a black balaclava, stocking, or scarf over the head, so that just the face shows.

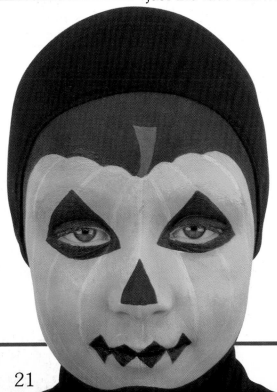

21

FOREST CREATURES

Lots of different animals live in forests. Here are just two of them for you to paint. People often think animals behave like humans. We think owls are wise and foxes are crafty. How true do you think this is?

OWL

1 To start, paint a light brown, feather-shaped area around each eye with a brush. Color in a diamond-shaped, bright yellow beak on the tip of the nose. Paint a black nostril on either side of the beak.

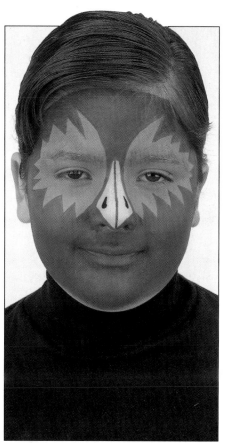

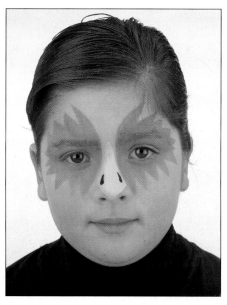

2 Paint a line down the middle of the beak. Then color the rest of the face with reddish-brown paint.

3 Mix some dark brown paint. With a fine brush, paint joined-up U-shapes all over the face to look like feathers. Paint an outline around the light brown areas around the eyes. Put a blob of dark brown paint in the middle of each feather. Paint the hair to match the face.

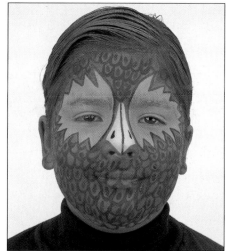

Costume ideas
Make tufts of feathers from brown cardboard or felt and pin them to the hair with hairpins. Make wings from two pieces of brown fabric and attach them to the sleeves of a shirt.

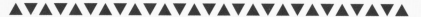

Handy hint
When painting in the U-shaped feathers, do not make short strokes with the brush. Paint each line without stopping. This will make the shapes clean and sharp.

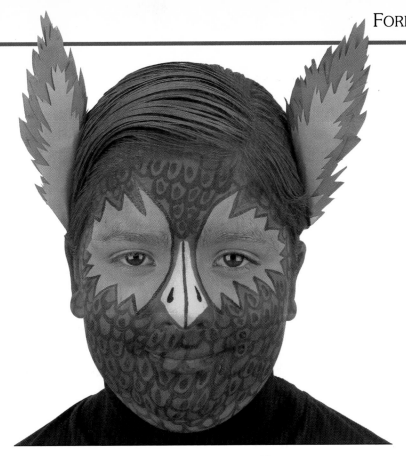

FOX

1 Mark the outline of the fox's face – the curved lines across the cheeks and rectangles around the eyes. With a brush, fill in the area around the eyes with cream-colored paint. Fill in the top half of the face with reddish-brown paint.

2 Paint the bottom half of the face in the same cream color. Using a fine brush, draw in eyebrows with dark brown.

Costume ideas
Cut out pointed fox's ears from paper or cardboard. Cover them with felt in two shades of brown. Attach them to a headband.

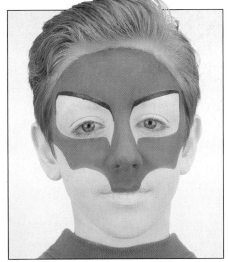

3 Paint the tip of the nose black. Add small dots and whiskers on both sides of the mouth.

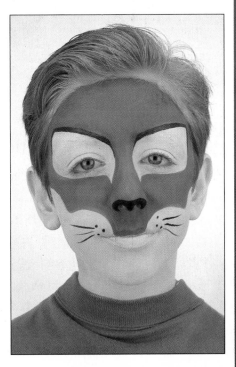

ELEMENTS

In ancient times, people thought the whole universe was made of four elements: earth, air, fire, and water. Of course, now we know that things are much more complicated than that! Here are designs based on fire and air.

Makeup need not be used only on the face. Water-based makeup is also perfect for body painting. The techniques are the same as for face painting, but a bigger sponge can be used. A small bath sponge will enable you to cover large areas quickly.

If the model has sensitive skin on his or her face, try body painting instead – leave the face free of makeup.

Clothes

Ask your model to wear a leotard that can be painted with water-based makeup (it washes out easily). Or try a one-piece swimsuit, bikini, or sleeveless top and shorts. You will need plenty of space for body painting, and you should put newspaper and towels on the floor to catch any drips.

FIRE

1 Sponge yellow paint all over the body and face. Outline red flame shapes all over the body. Before they dry, smudge the lines with a dry sponge to make them look softer.

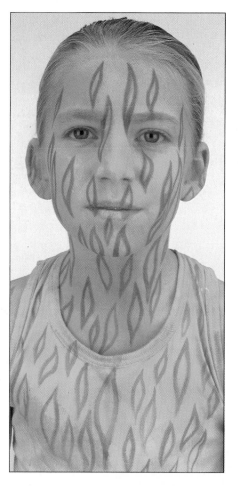

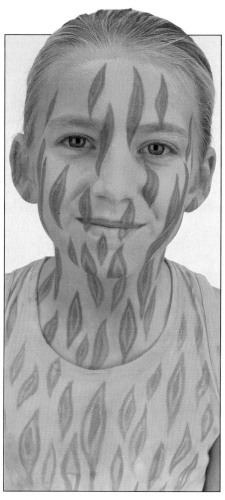

2 Paint light orange inside each flame shape, then paint dark orange in the middle.

3 Finish by coloring your model's hair with yellow, red and orange paints. Twist the hair into a flame shape. Use hairspray to make it stand up.

AIR

1 Mark the outlines of the rainbows and sponge pale, sky-blue paint onto the face and body around them. Sponge some dark blue paint over the pale blue. Dab white clouds all over the face and body to break up the blue.

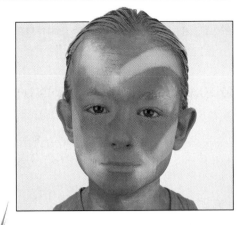

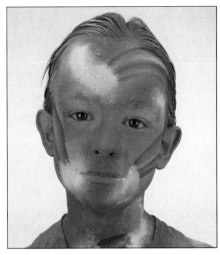

2 Paint in the seven rainbow colors. Start with red for the outer stripe, then add orange, yellow, green, blue, indigo (dark purplish-blue), and violet (pinkish-purple).

3 Paint black birds using a small brush to make V-shapes. Color the hair with blue paint, or add a curly blue wig.

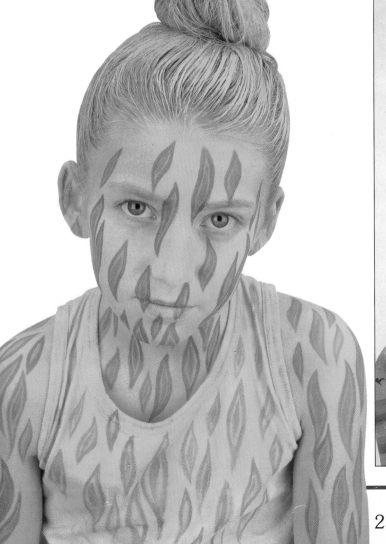

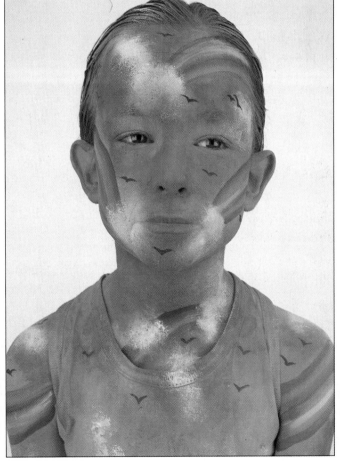

25

SHAPES AND PATTERNS

The world is full of shapes, patterns, and colors. Look around you. Can you see stripes, spots, and squares? Have you learned about squares, rectangles, triangles, and circles in school?

It can be fun to paint shapes and patterns on a face. Follow these steps to paint any of the patterns shown here – or make up your own patterns.

1 Outline the pattern on the face with a brush.

2 Paint in the shapes, using any colors you want.

3 If the design needs a background color, fill it in. If not, finish by outlining the shapes in black or any other dark color.

Costume ideas
Wear any bright top or T-shirt in a color to go with the face.

STRIPES

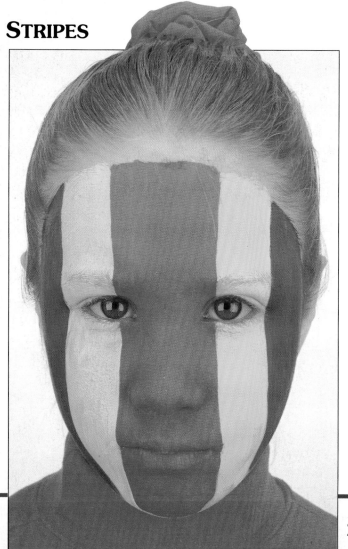

TRIANGLES

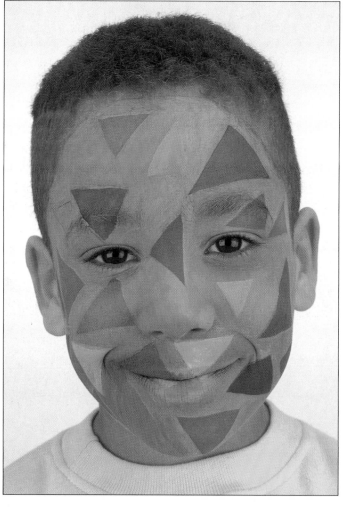

SQUARES

CIRCLES

THE HISTORY OF MAKEUP

Makeup has been used for thousands of years by many different people and for many different reasons. It has been used by people celebrating special occasions such as weddings and festivals, and by actors appearing in plays and movies. Most of all, it has been used by people to make themselves beautiful. However, fashions change, and what may have been seen as beautiful hundreds of years ago might not seem so lovely today!

Early makeup

The use of makeup probably began in China, but the earliest evidence we have of it comes from ancient Egypt. The ancient Egyptians originally used makeup to protect their skin from the harmful effects of the sun. They also made their eyes look bigger with heavy black eyeliner and painted their hands and feet with a red dye called henna. This practice continues today in Asia, where women who are about to be married have beautiful red patterns painted on their hands and feet.

Sixteenth-century faces

In Europe in the sixteenth century, people used paint made from lead to whiten their faces and painted bright red circles on their cheeks. They covered the whole face with egg white, which got hard when it dried. This

might have led to the expression "to crack a smile." People also thought veins showing through the skin were attractive – so they painted them on with blue paint!

Eighteenth-century faces

In the eighteenth century, in Europe and America, makeup for women – and men – was extremely common. People continued to use lead paint to whiten their faces, even though they knew it was very harmful and could eventually kill them. Small black "patches," or beauty marks, were very fashionable. People used them to cover up scars and marks.

Nineteenth-century faces

By the end of the eighteenth century, makeup was so common that attempts were

made to stop people from wearing it. In England and some states in the U.S., laws were passed to prevent people from using makeup.

Twentieth-century faces

In the twentieth century, there have been all sorts of makeup fashions. The 1960s saw pale skin, heavy black eyeliner, and false eyelashes; in the early 1970s people painted their faces with bright colors and glitter; in the early 1980s, striking punk makeup was in fashion.

Try to find out more about makeup in the past. Look at old paintings in books and museums. Ask you parents and grandparents about the makeup they wore when they were younger.

Here are two historical faces for you to paint:

EIGHTEENTH-CENTURY FACE

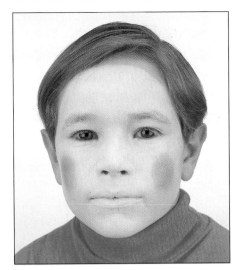

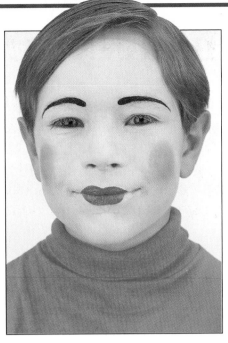

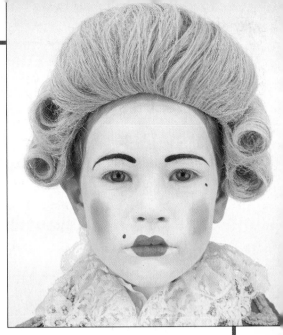

1 Sponge on a white base. Dab two red circles on the cheeks with a sponge.

2 Use a brush to paint two black eyebrows and bright red, bow-shaped lips.

3 With a small brush, dot on two black beauty marks. Put on a white, powdered wig – you can rent one from a costume shop.

EGYPTIAN FACE

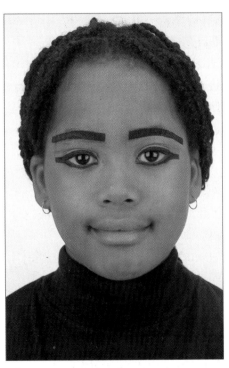

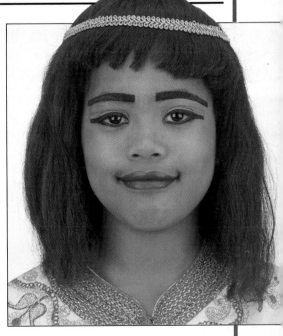

1 Sponge on a light brown-yellow base and yellow-orange cheeks (if your model already has dark skin, you will not need to apply a base). Paint green eyeshadow on the eyelids with a brush.

2 Paint on thick black eyebrows and heavy black eyeliner, extending the lines out to the sides of the face.

3 Color the lips dark red. Rent a straight black wig with a heavy fringe from a costume shop. Tie a piece of gold braid or ribbon around the head.

AND FINALLY...

BUSY BEE

Here is a simple, quick face to finish with. Add some antennae and some wings – and you'll have a busy little bee!

1 Using a big brush, paint wide yellow stripes across the face.

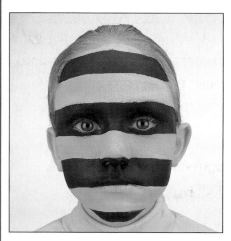

2 Rinse out the brush and paint black stripes between the yellow ones.

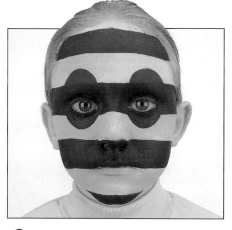

3 Paint a black circle around each eye.

Costume ideas

Stick black tape or cardboard across a yellow polo shirt to make a striped body. Make antennae by piercing holes in two Ping-Pong balls (ask an adult to do this for you). Stick pipe cleaners into the holes. Paint the antennae black and attach them to a headband or a black stocking worn on the head.

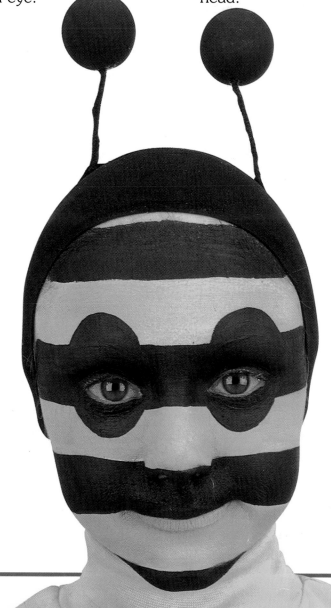

MAKE YOUR OWN DESIGN

If you had fun painting the faces in this book, you might enjoy making up some of your own.

Will you paint a person? Will it be a real or imaginary character? Or will you paint an animal, a scene, or a thing? To get ideas you can look in magazines, books, or even the telephone book. The library is a good place to start if you want to get your ideas from words and pictures.

You can also look at paintings in museums and galleries, at animals, and at the city or country scenes around you.

Once you have an idea you like, make a few test drawings on paper. First, draw an oval that's about as big as the face you'll eventually paint. If you like the shape, draw over it with a marker, so when you erase mistakes later, the face outline will remain.

Now lightly sketch in the eyes, nose, and mouth. (Remember that the eyes are about halfway down the face.) Next, pencil in the outline of your design. Erase and start over if you make a mistake.

Once your design outline pleases you, color it in with crayons, markers, paints, pastels, or anything that lets you see how the colors will look. If you don't like the first color combination you come up with, trace the design outline onto another piece of paper and try again.

Now you are ready to paint your live model's face. Don't forget to put a smock on the model in case of spills. How does the design look on a person instead of paper? You might change things as you go. Cold cream does a good job of taking makeup off quickly. Don't forget to tell your model to *sit still* because there's an artist at work!

Once the face is done, you're ready to complete the rest of the costume. As you saw earlier in this book, you don't need fancy things to make a great costume. Simple clothes with interesting details will often do the trick.

You could make a wig out of strips of newspaper pinned to an old stocking top. You could stuff straw up your sleeves to go with a painted scarecrow face. For a princess, look for a long skirt in a second-hand store. Does your monster have scaly paws? Then how about attaching painted cardboard to a pair of old gloves?

The wilder your imagination is, the wilder your painted faces and costumes will be. So let your mind go wild and have some fun.

BOOKS TO READ

Baker, Wendy. *The Dressing Up Book.* Activities. New York: Thomson Learning, 1994.

Chaudron, Chris and Childs, Caro. *Face Painting.* Tulsa, OK: EDC Publishing, 1993.

Freeman, Ron. *Makeup Art.* Fresh Start. New York: Franklin Watts, 1991.

Pryor, Nick. *Putting on a Play.* New York: Thomson Learning, 1994.

Snazaroo. *Five Minute Faces: Fantastic Face-Painting Ideas.* New York: Random House Books for Young Readers, 1992.

INDEX

The entries in **bold** indicate subjects that are illustrated step-by-step.